New York State Empire State Games

Photo Essay

by

Donna White-Davis

In this year of Olympics, it is easy to become enthralled with those human endeavors of excellence. I created this book to show case how a country produces the values needed to compete on a world effort while building community health and strength, team cooperation, good sportsmanship, grace in winning and losing, mutual respect for effort, and the sheer love and joy of challenging one's body and soul.

I was given press privileges to photograph the Empire State Games in 2001 held in Oneida and Herkimer counties. Photographing the events can be equal the challenge. Over 40 events in five locations in three days and over 20 miles takes diligence timing, judgment and a passion for photography and sports bred in my own childhood and young adult sporting opportunities. I want to dedicate this book to my Mom and Dad, school and community, my college, my friends and colleagues with whom I learned and shared sports.

It takes balanced working schedules to free adults in my village to give us the opportunities, coaching and supervision, healthy, safe homes and lifestyles that filled our time we chose to give our bodies hearts and minds the training and joy needed to take us through life. Celebrate the gift of an opportunity for sport in your lives, be it as simple as breaking into a run home from school, jumping high to reach a limb of a tree, tumbling across a lawn or diving into a clear cool brook. Join a team, be coached, and be challenged lovingly by a friend. Sports feel good. May our lives never stop being filled with that energy.

Love, Donna

All photographs copyright 2001 Donna White-Davis

Gymnastics

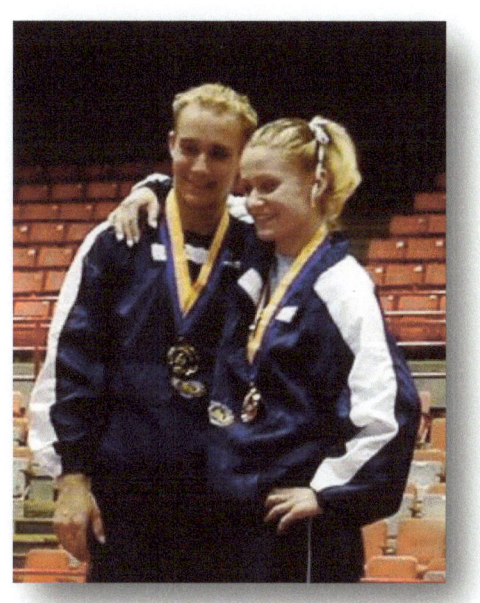

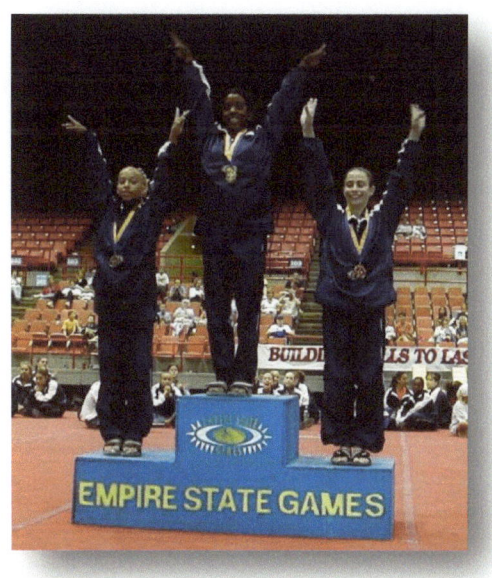

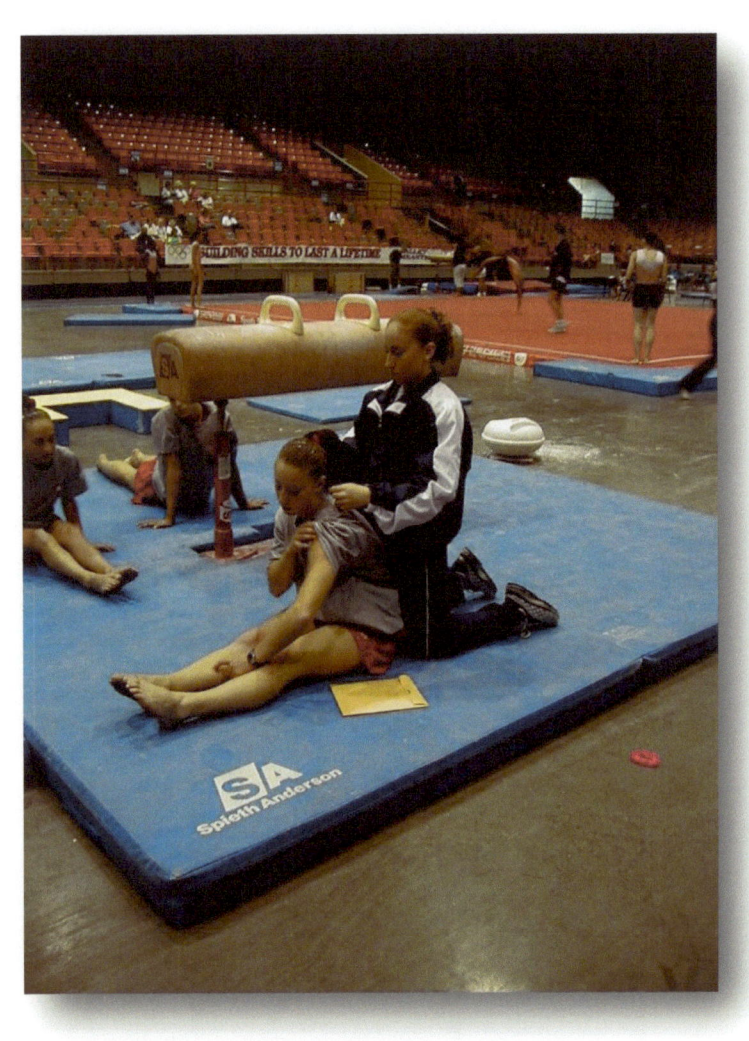

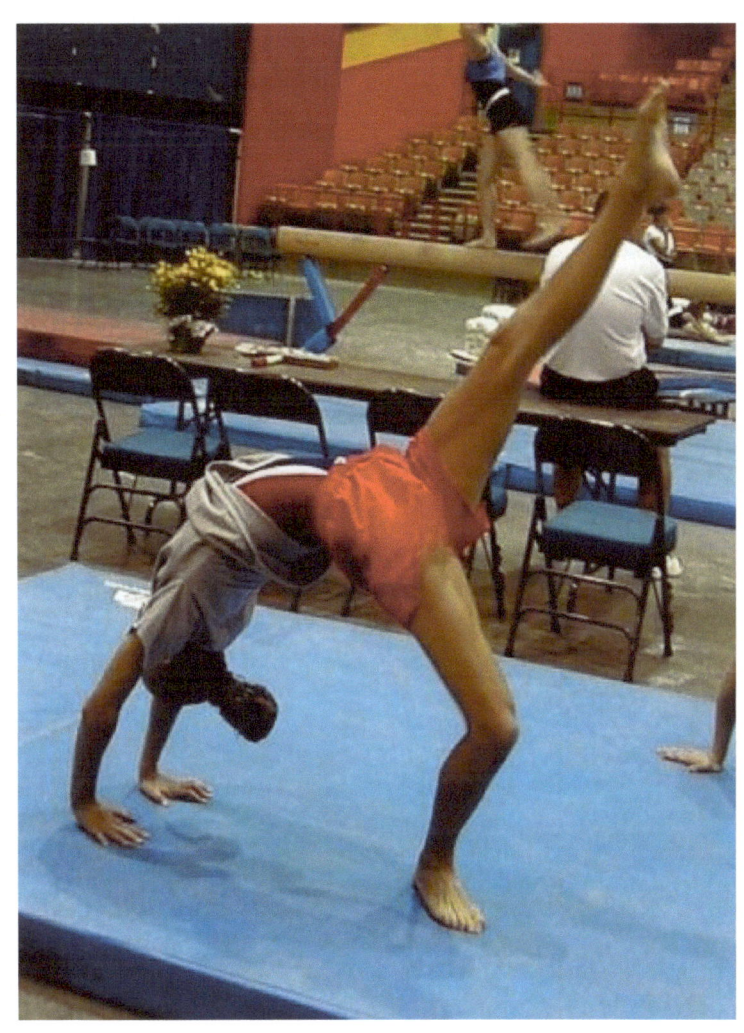

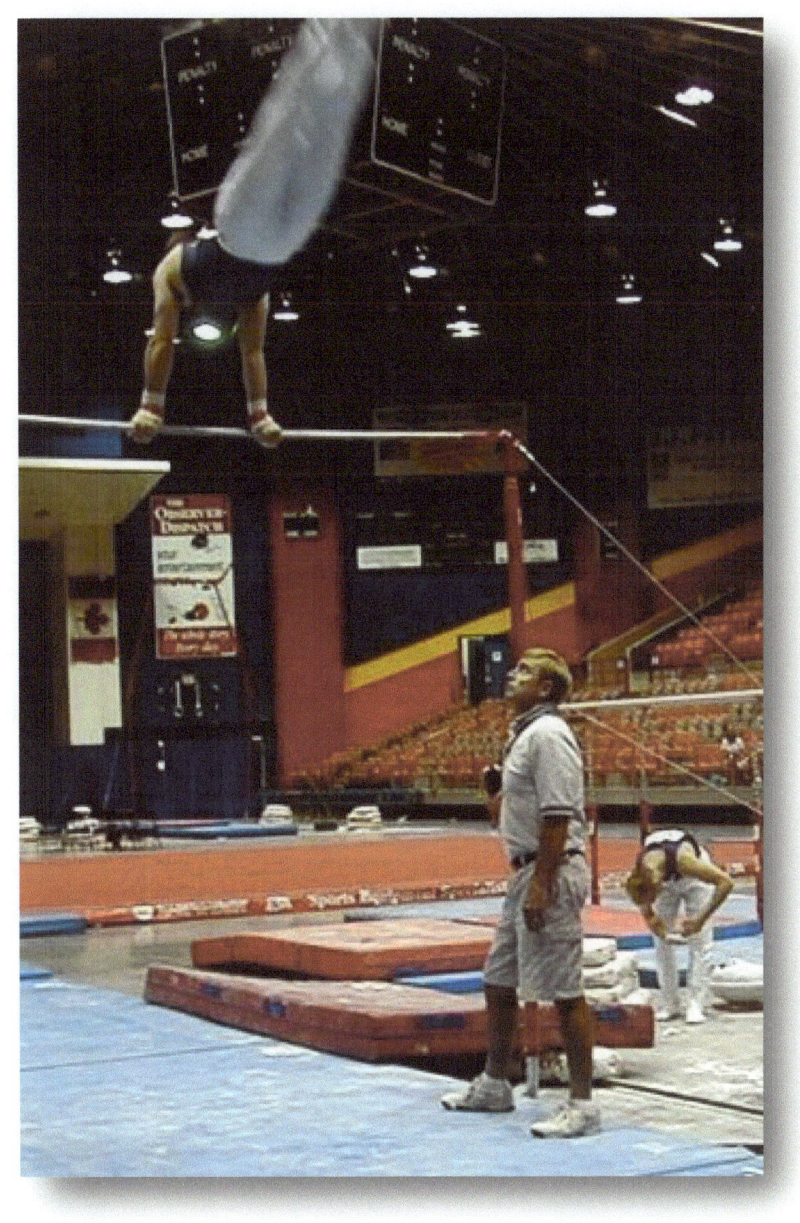

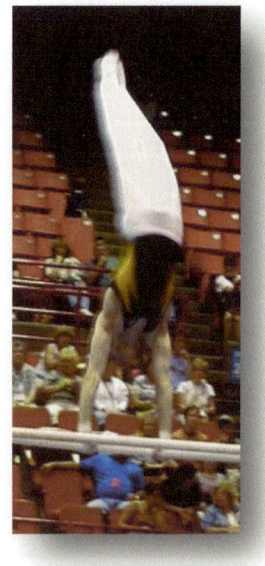
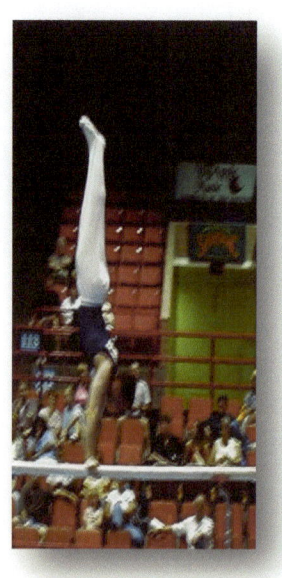

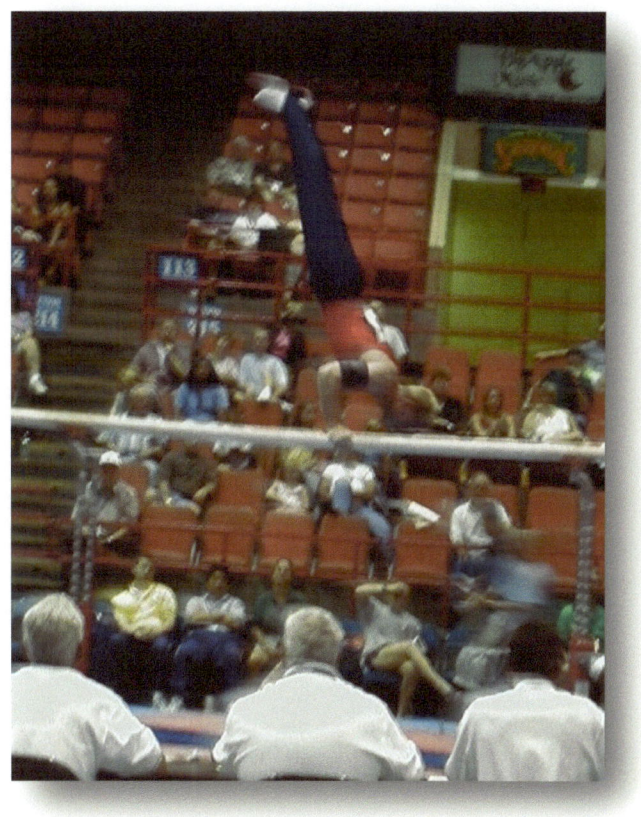

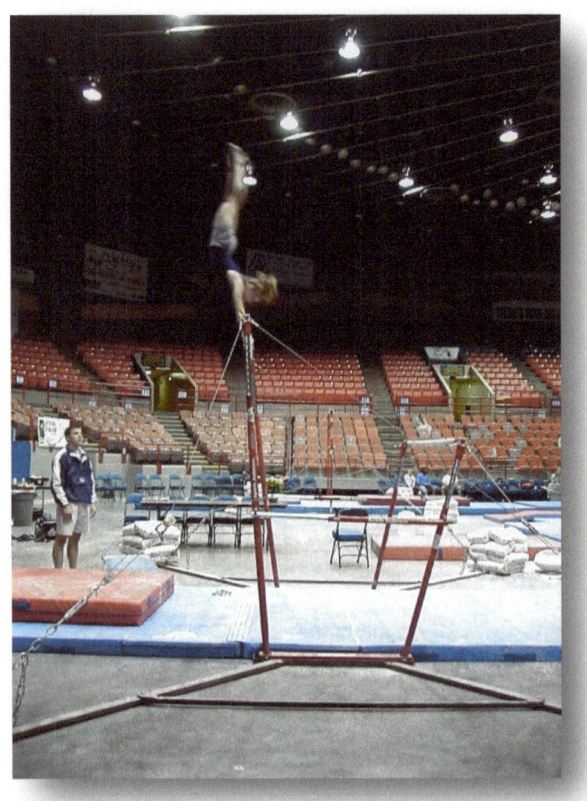
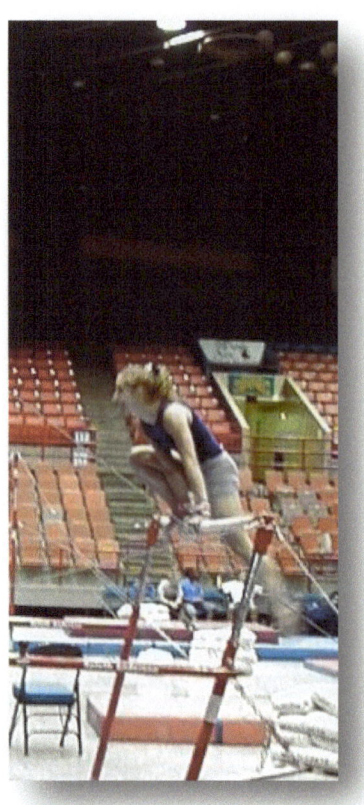
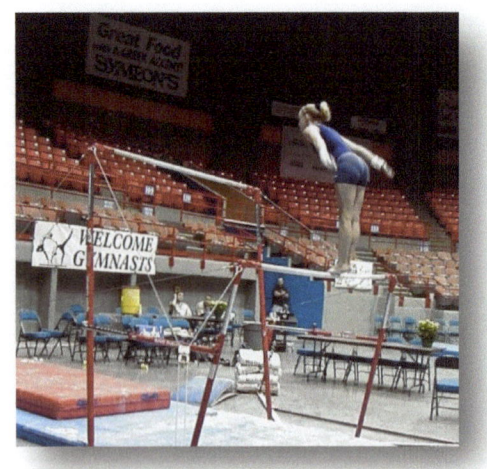

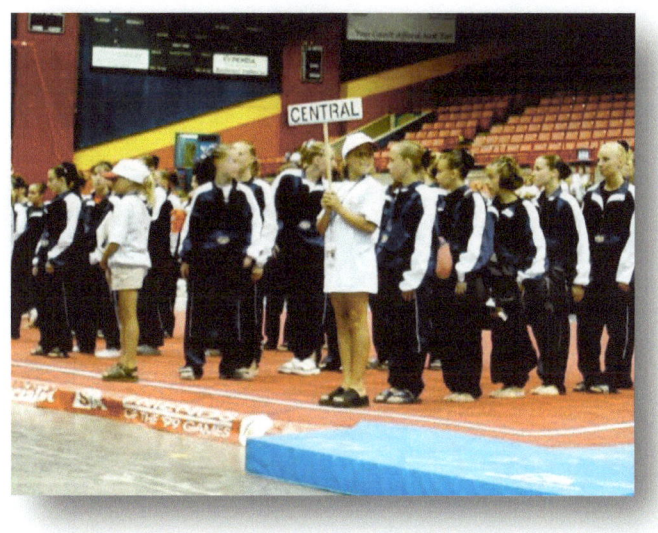

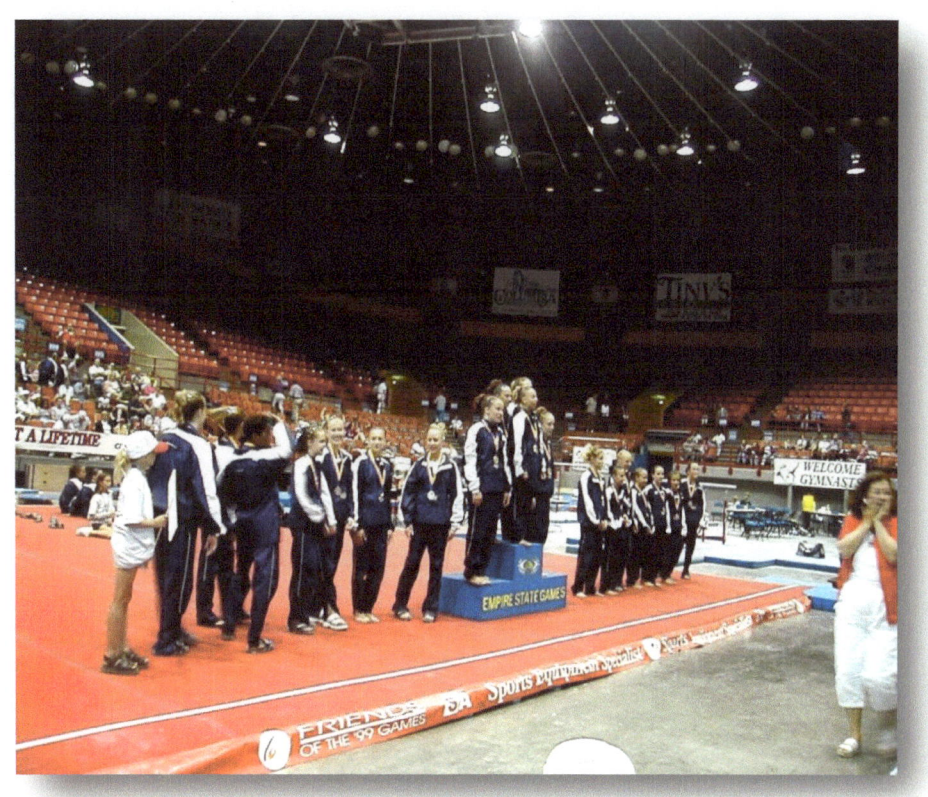

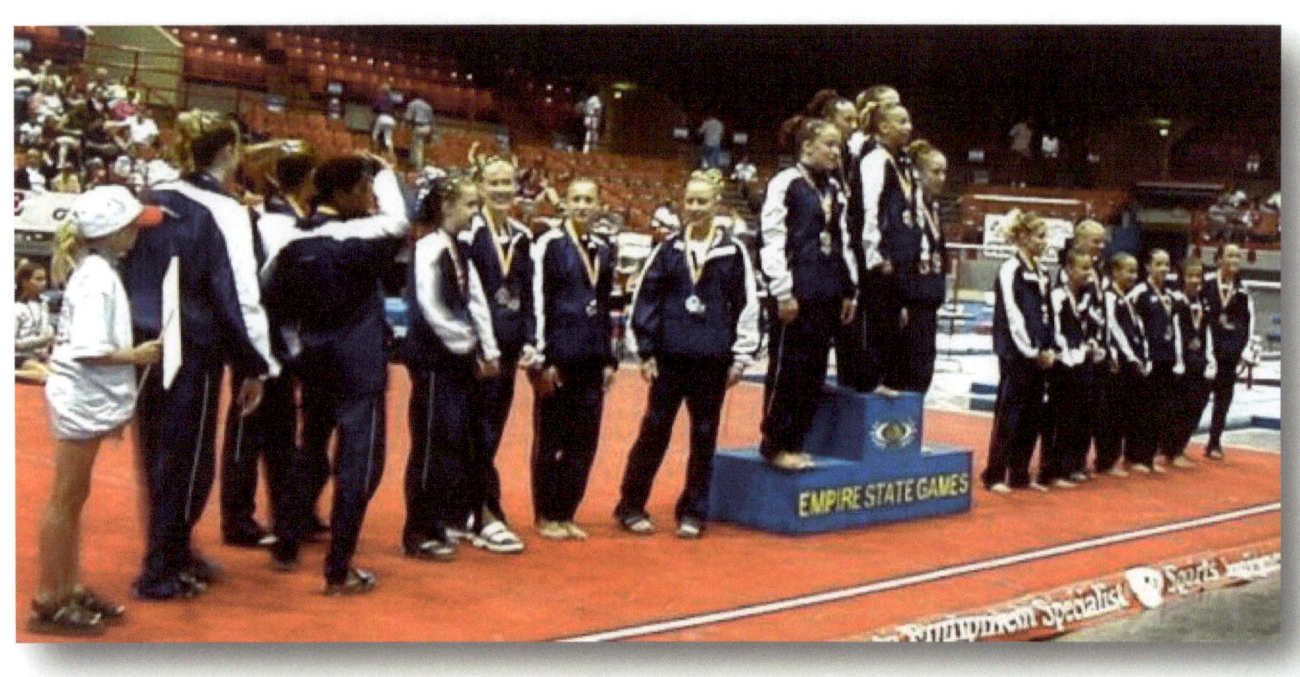

Fencing

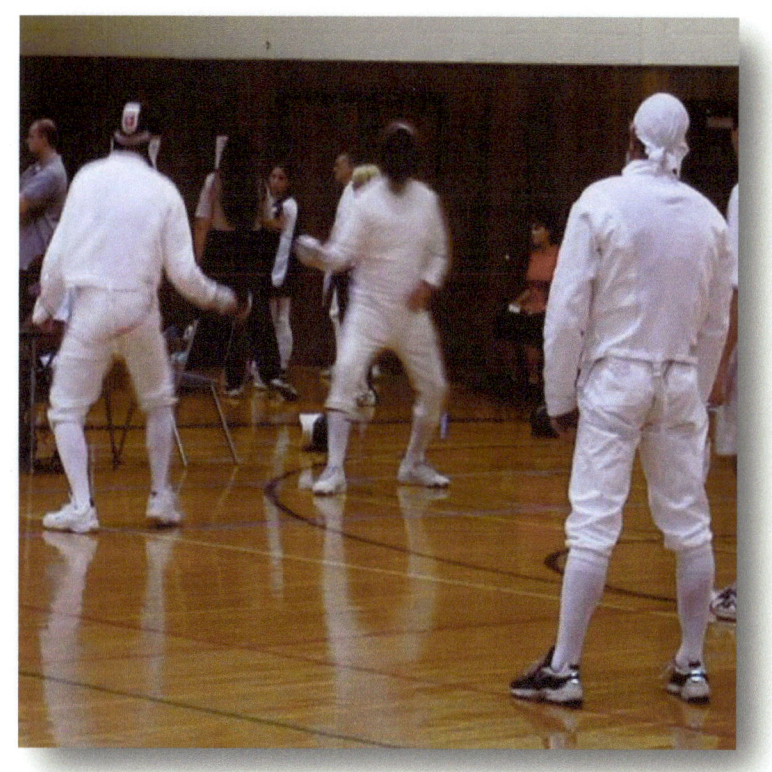

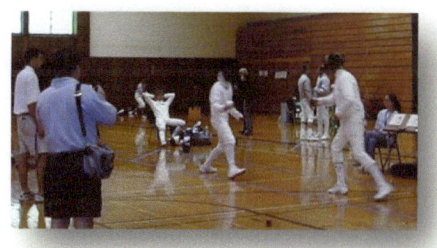

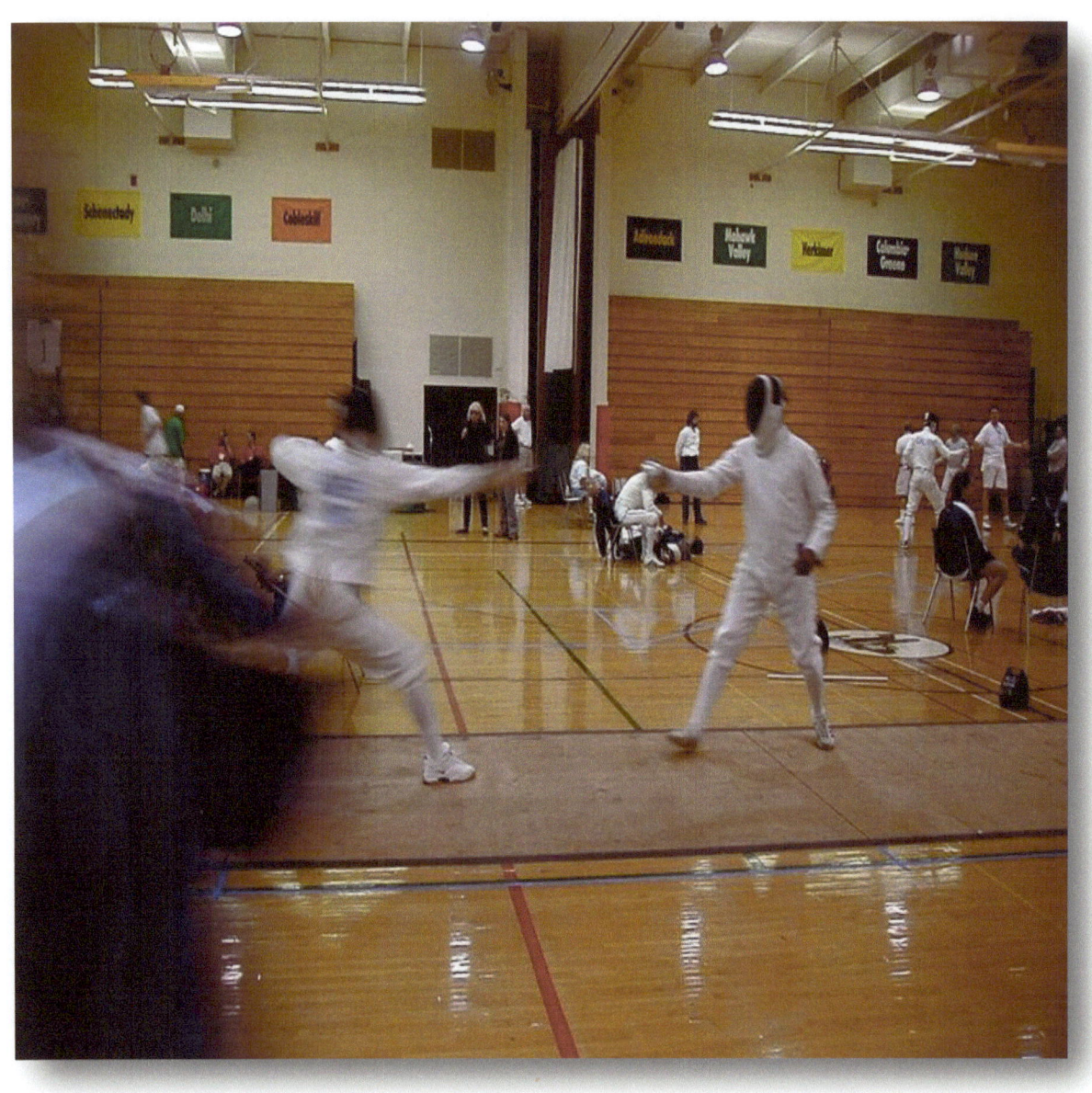

Tennis

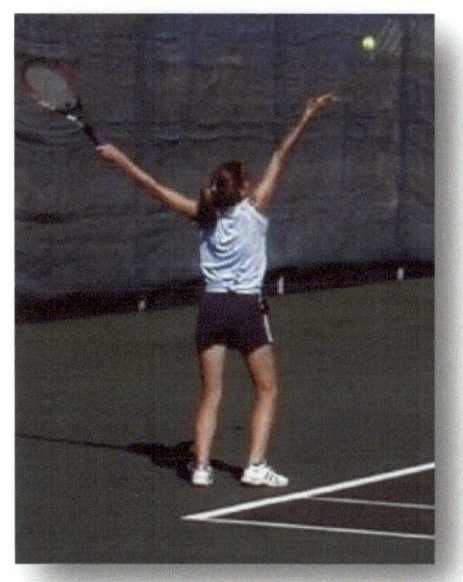

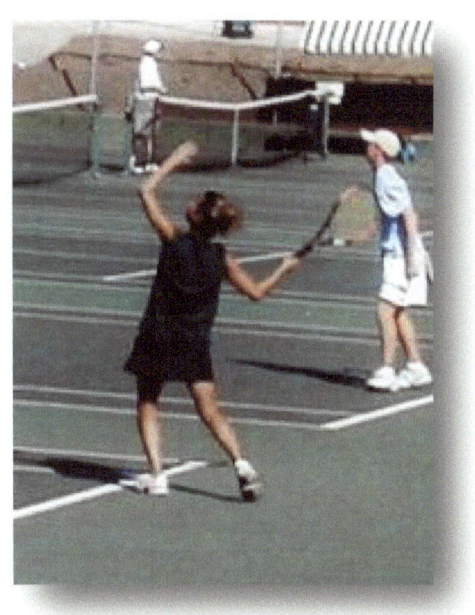

Baseball

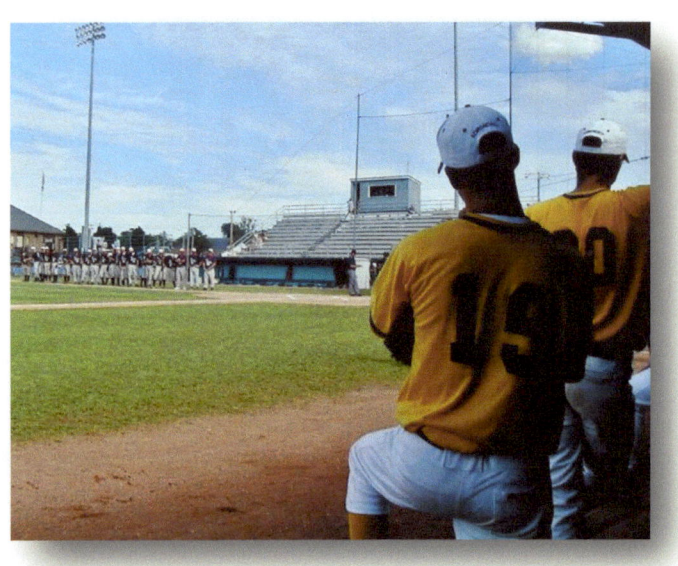

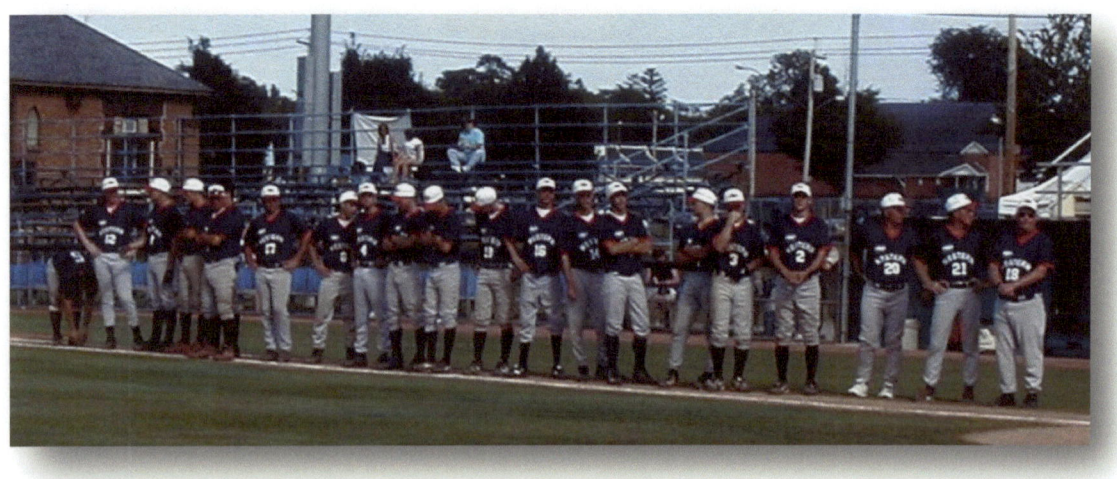

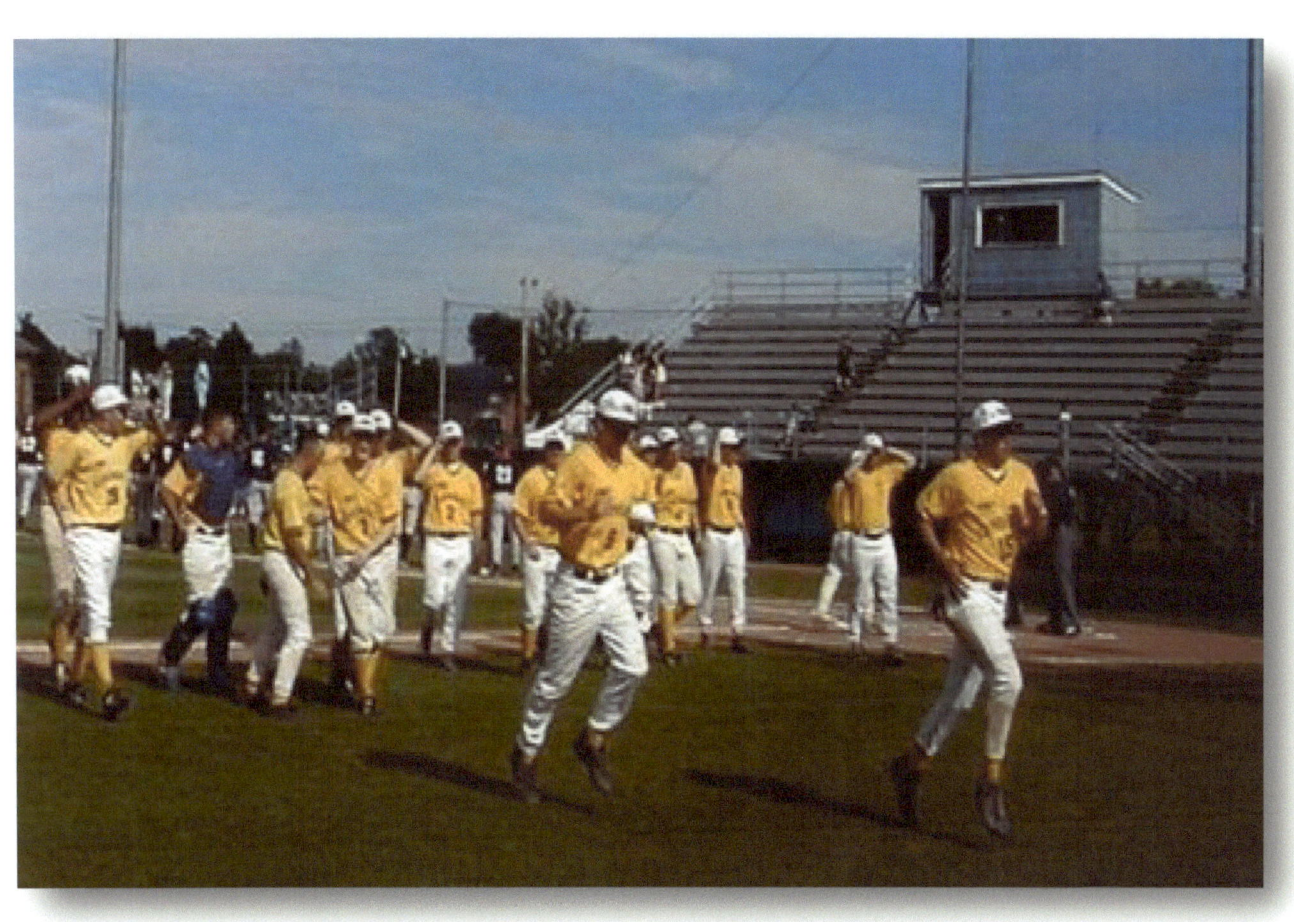

La Crosse

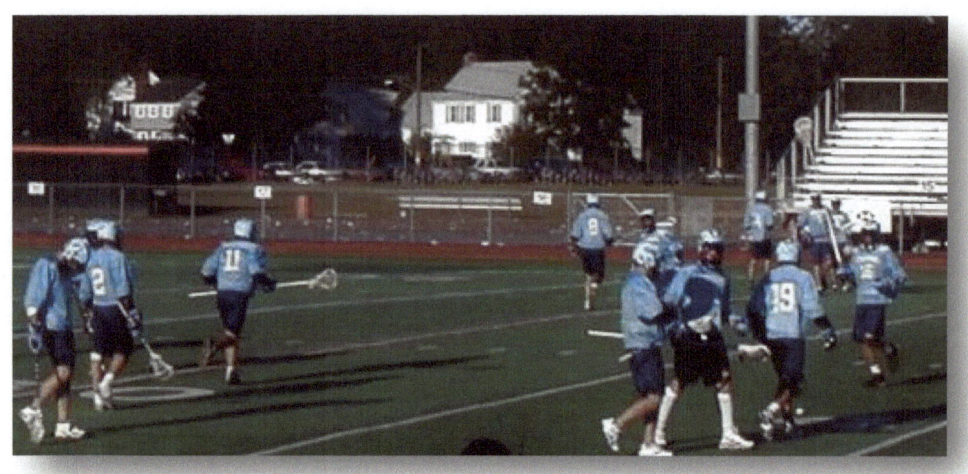

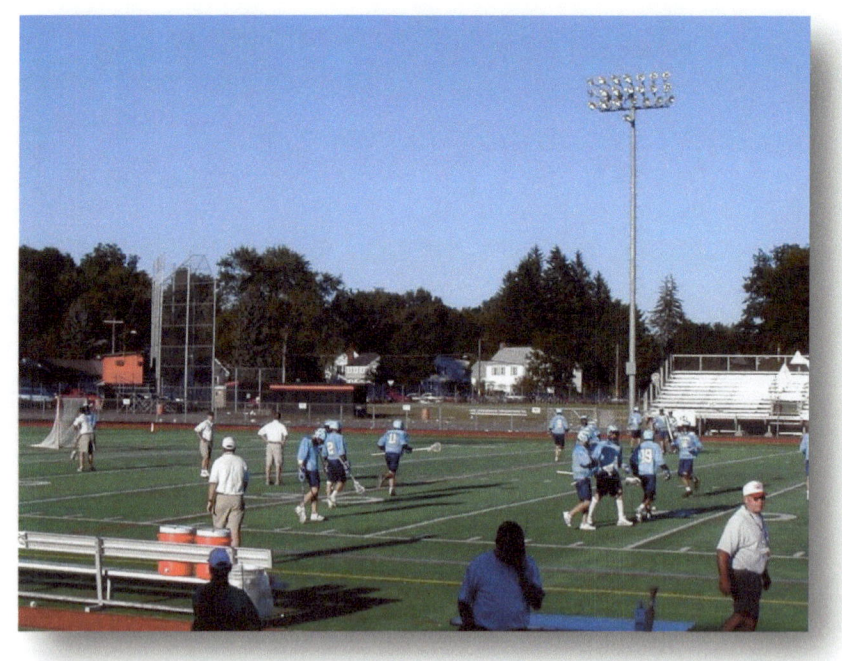

Field Hockey

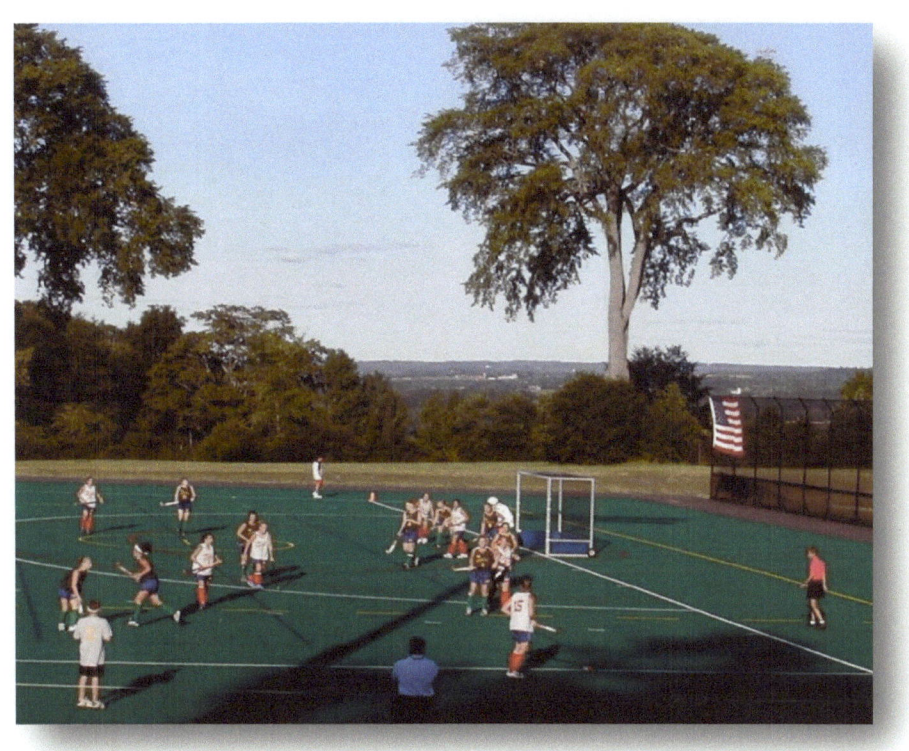

Soccer

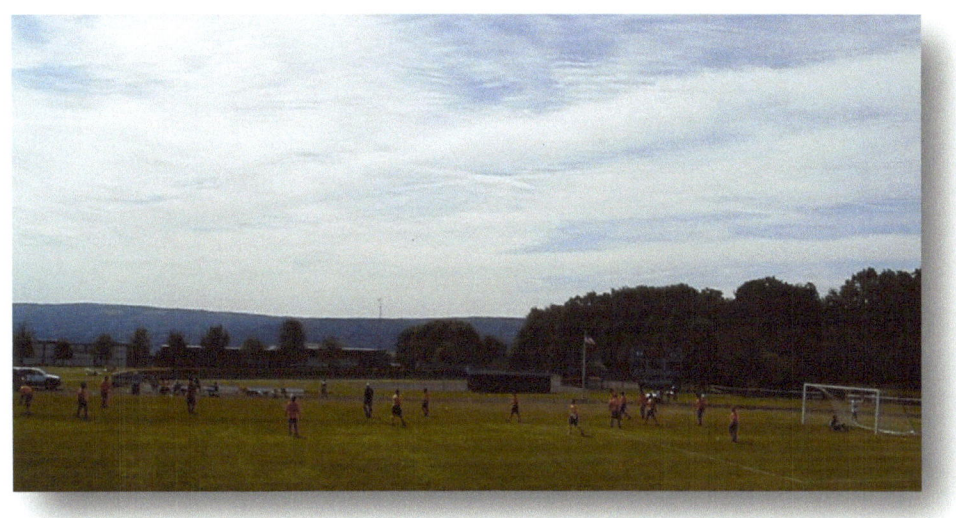

Synchronized Swimming

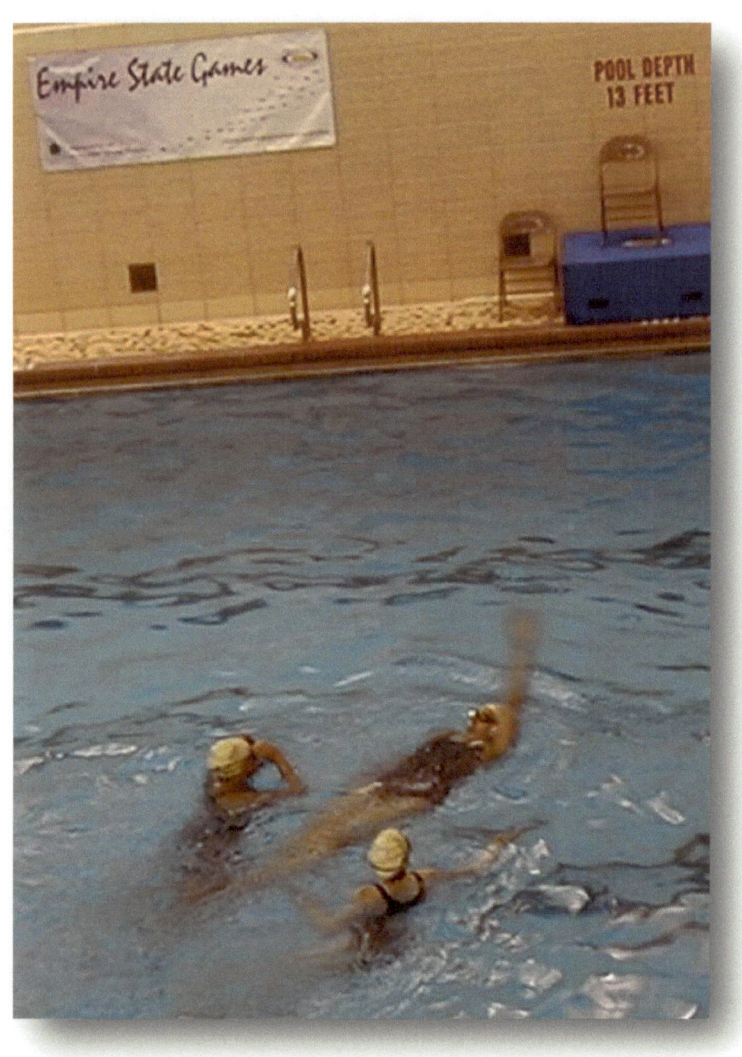

Water Polo

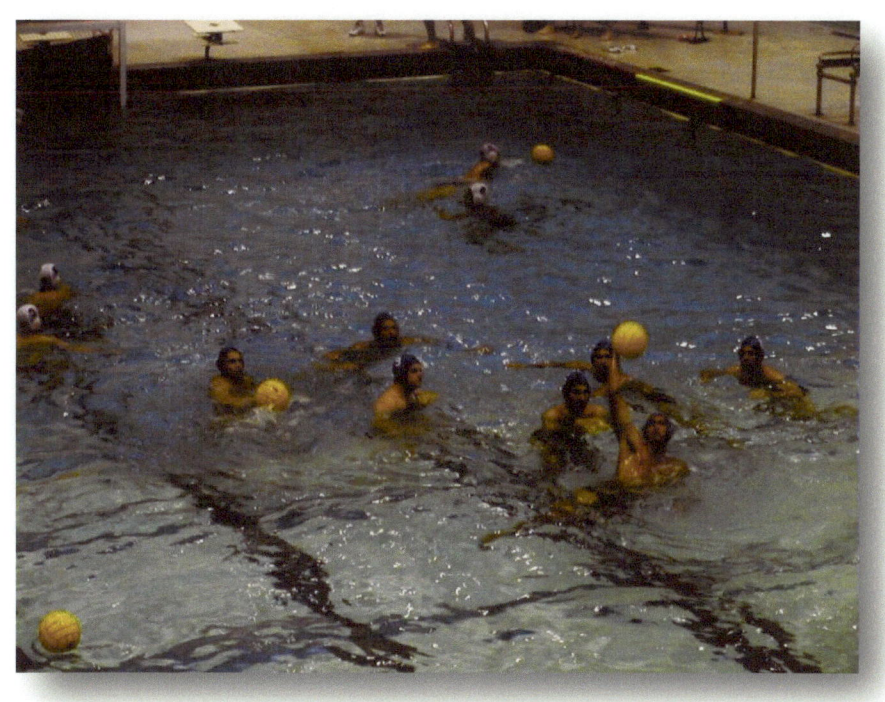

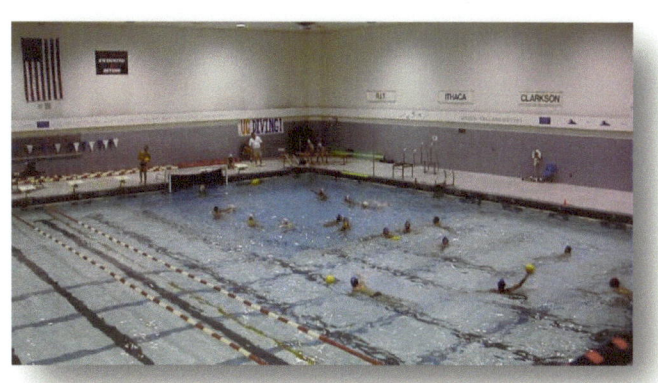

Diving

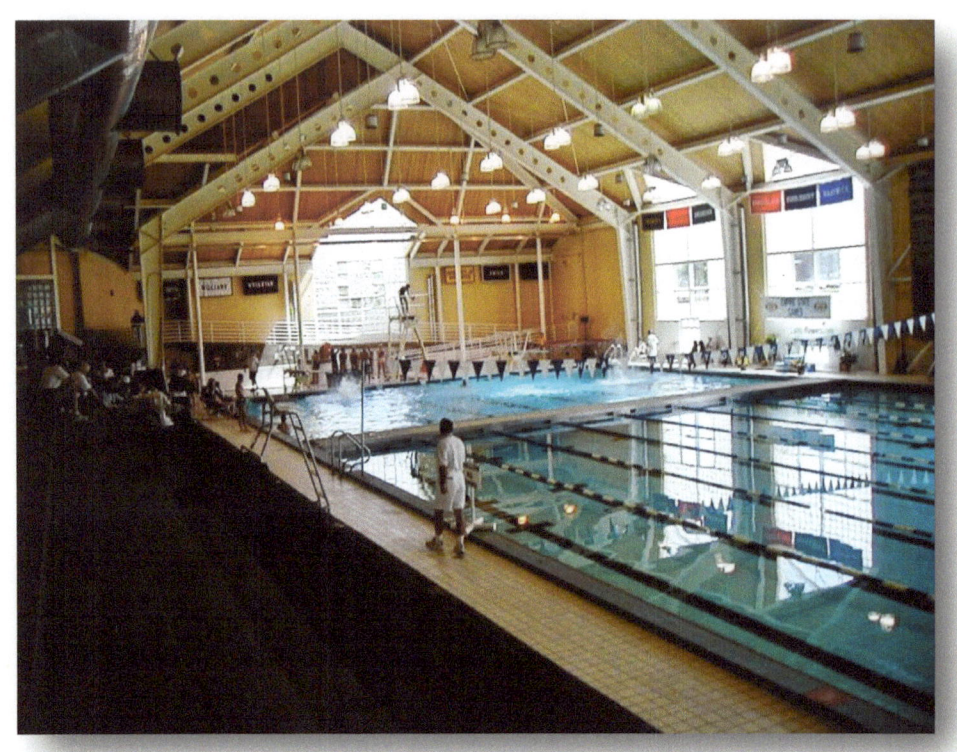

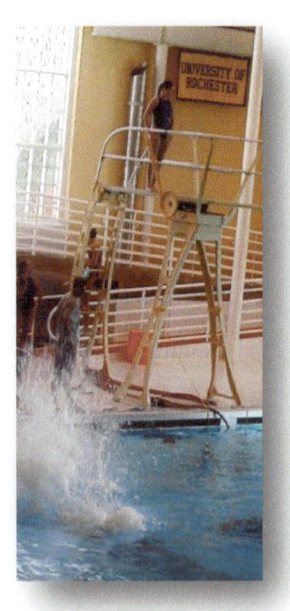

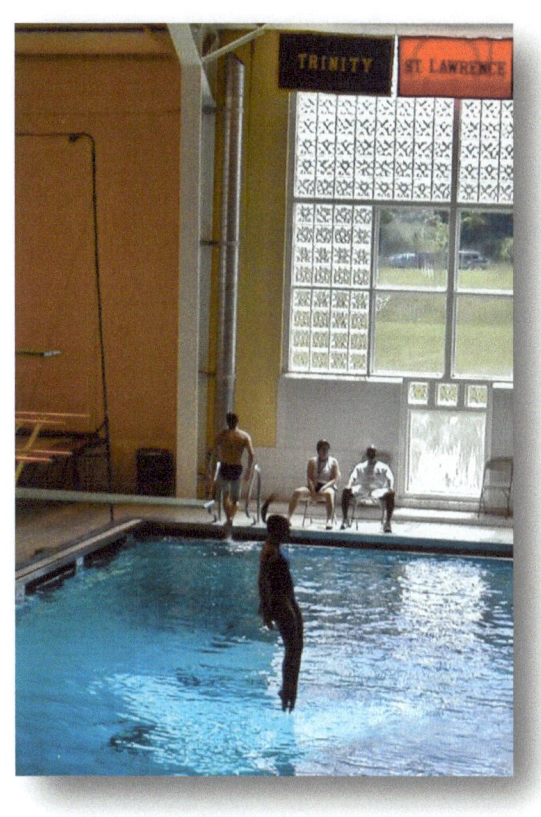

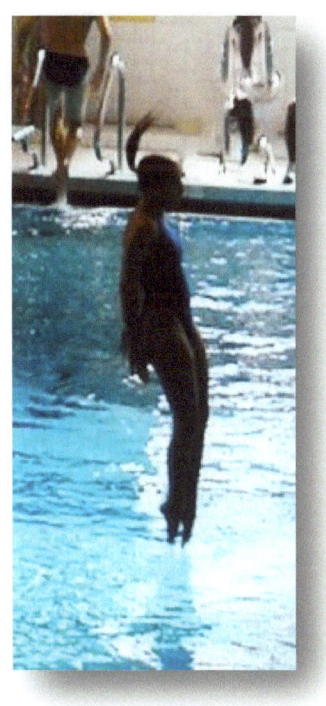

Shooting

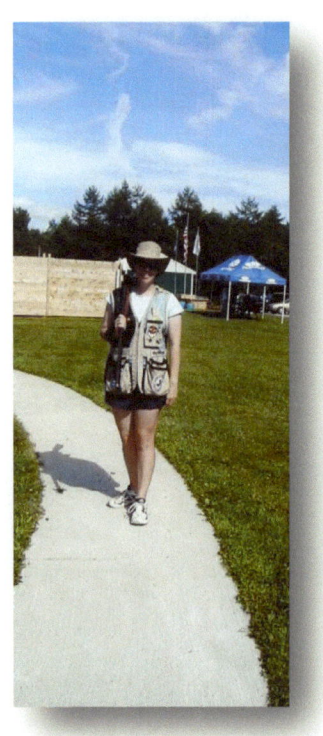

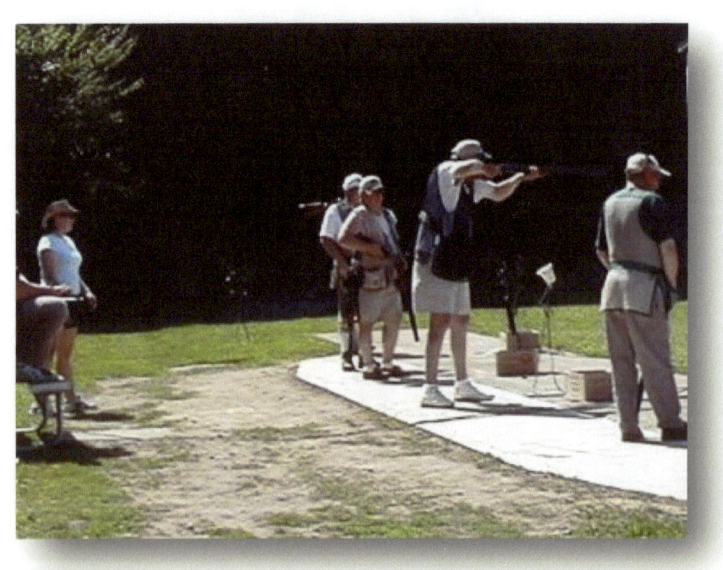

Sailing and Canoeing

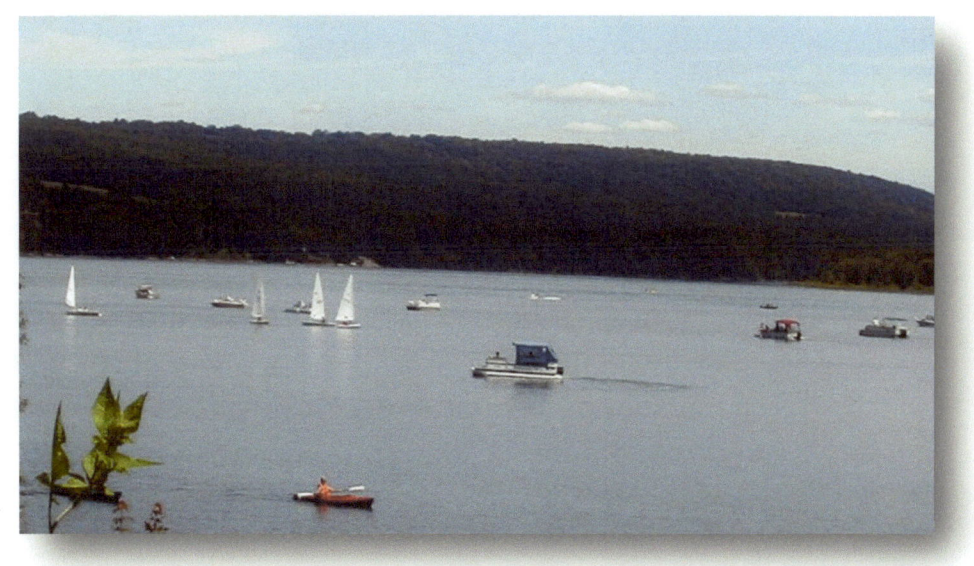

Volleyball

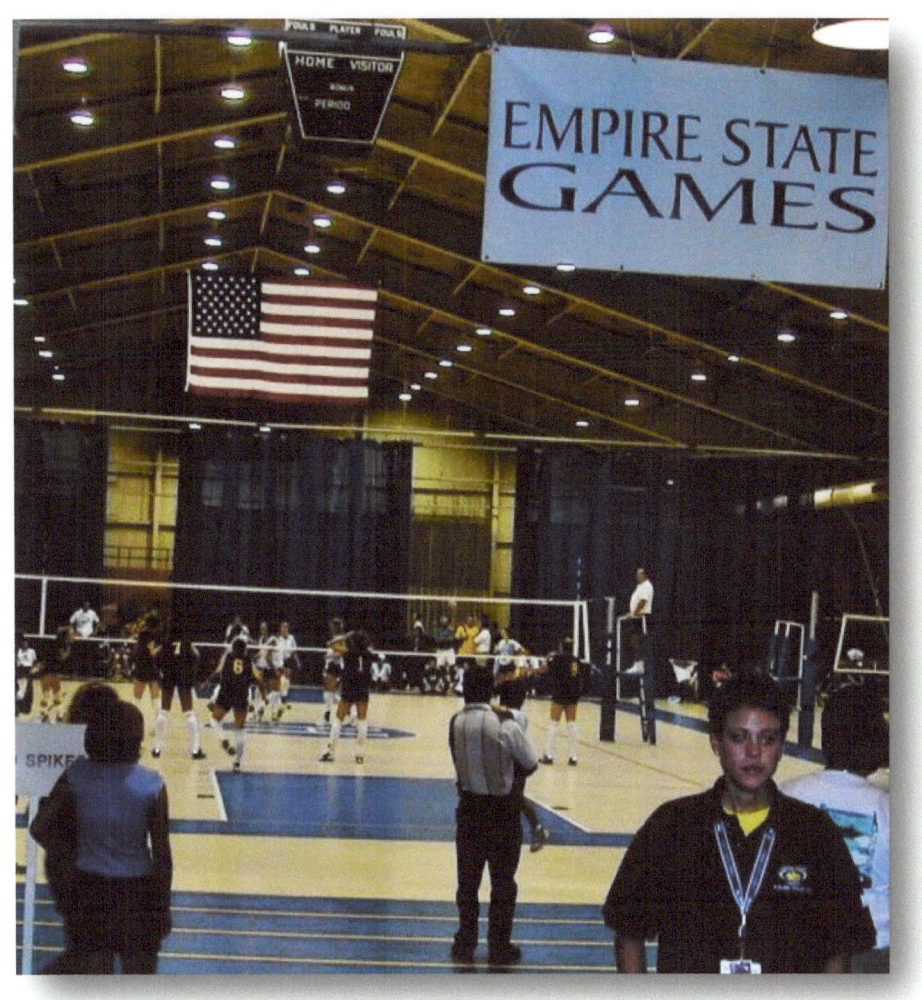

Basketball

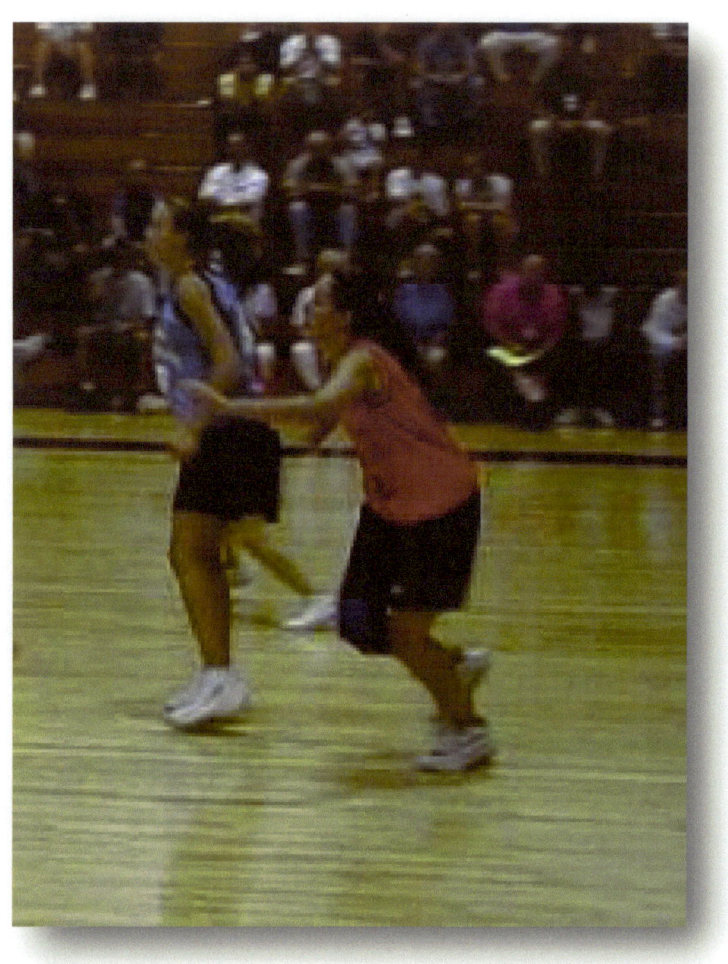

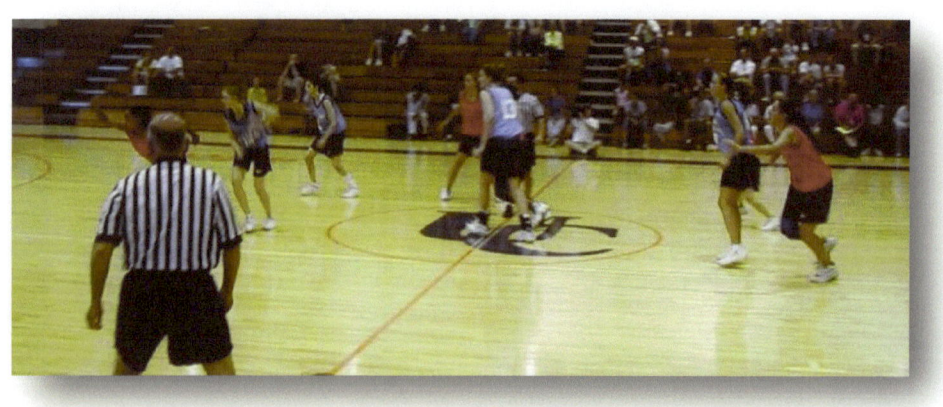

Spectators

Empire State Games

Regionally planned by New York State to showcase the variety and excellence of sports in New York State while showcasing New York State's youth in environmentally safe and beautiful regions. This event took place in the Central Region in 2001 however, each region in New York has hosted at least one Empire State Games event. For the future, let us promise to dedicate ourselves to preserving both.

All photographs copyright 2001 Donna White-Davis

The author welcomes correspondence at

Donna White-Davis

P.O. Box 758

Woodstock, New York 12498

donnawhitedavis@hotmail.com

845 901-5603

www.ingramcontent.com/pod-product-compliance
Lightning Source LLC
Chambersburg PA
CBHW041257180526
45172CB00003B/885